Brian Webb & Peyton Skipwith

Peter Blake

DESIGN

Antique Collectors' Club

Design Series format by Brian Webb
Design, Peter Blake © 2010 Brian Webb & Peyton Skipwith
Illustrations © 2010, Peter Blake
Sgt. Pepper's Lonely Heart Club Band © Apple Corps Ltd.

ISBN 978-1-85149-618-1

British Library cataloguing-in-Publication Data
A catalogue record for this book is available from the British Library.

Antique Collectors' Club
www.antiquecollectorsclub.com

Sandy Lane, Old Martlesham,
Woodbridge, Suffolk IP12 4SD, UK
Tel: 01394 389950 Fax: 01394 389999
Email: info@antique-acc.com
or
ACC Distribution,
6 West 18th Street, Suite 4B,
New York, NY 10011, USA
Tel: 212 645 1111 Fax: 212 989 3205
Email: sales@antiquecc.com

Acknowledgements
With thanks to Austin Desmond, Coriander Studio,
Hazlitt Holland Hibbert Heejin No, and Waddington Gallery

**The cover design is reproduced from Pop Art specially
drawn for Design and endpapers from London to Brighton.
Enjoy, opposite, from WeekLink calendar 2000.
Page 6 Royal Academy, poster, 1975, detail.
Page 42-43 Madame Tussauds, poster, 1968.
Pages 64-65 rejected cover design for Gordon Burn's novel Alma Cogan, 1992**

Published by Antique Collectors' Club, Woodbridge, England
Design by Webb & Webb Design Limited, London
Printed and bound in England

enjoy

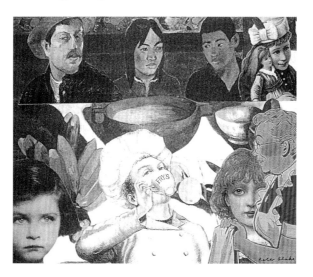

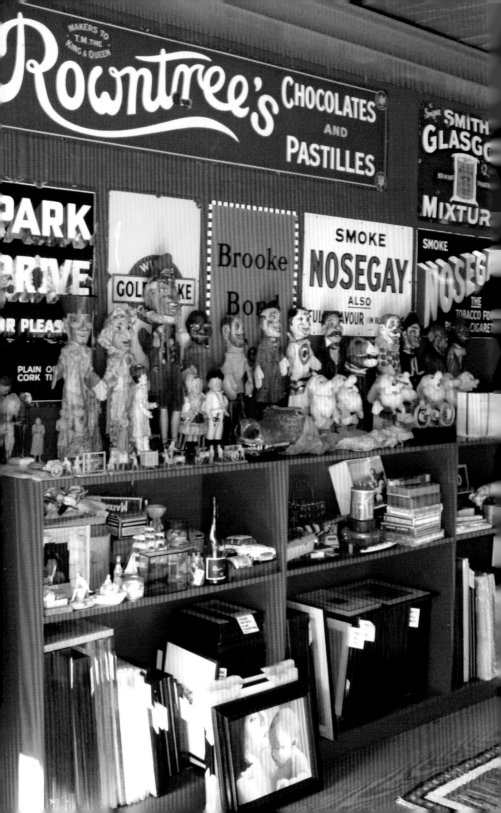

Foreword

In the autumn of 1961 I started at Liverpool College of Art as a
sixteen year-old design student. At the same time Roger McGough and
the other Liverpool Poets were performing at Hope Hall, the Beatles
were playing lunchtime sessions at the Cavern, and a few hundred yards
away at the Walker Art Gallery, Peter Blake had just won first prize in
the junior section of the John Moore's competition for his Self Portrait
with Badges.

Although I was a regular at the gallery, this was the first painting I
was aware of that spoke my language: the graphics of badges and fan
magazines. And denim.

I learned later that Peter had also trained as a designer before joining the
Painting School at the Royal College of Art and like many earlier RCA
students, including Edward Bawden, Eric Ravilious and Enid Marx, all
taught by Paul Nash, he followed Nash's rule in making no distinction
between self-initiated work and commissioned design. In fact I find it
almost impossible to tell where Peter Blake's art ends and design begins.
He uses a visual language of found images, symbols and typography
to make work that is a celebration of the commercial world of design,
creating instantly recognisable 'Peter Blakes'.

His work is a reflection of his passion for collecting. His studio, part
reference library, part museum – a cabinet of curiosities – has been at
the centre of his life since his Self Portrait with Badges, now in
Tate Britain and sold in the gallery shop transformed
into a badge.

Brian Webb

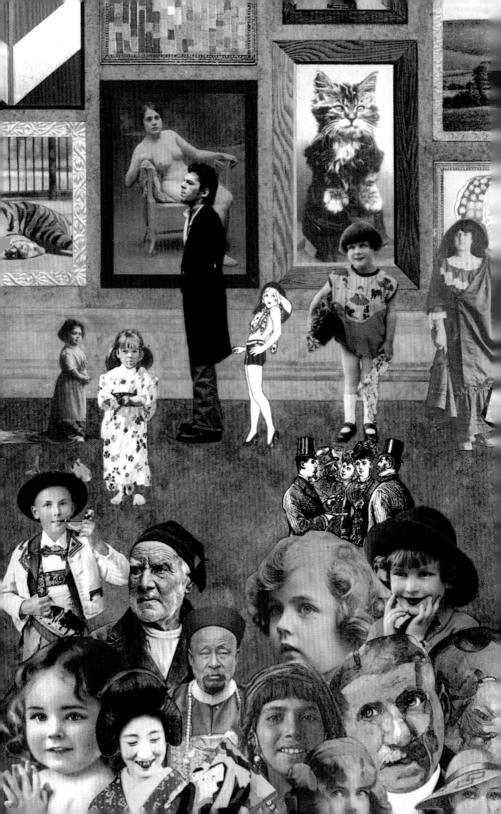

Design
Peter Blake

If we want to "prove ourselves worthy" of the clearly significant achievements of the past, we must set our own achievements beside them born out of our own time. They can only become "classic" if they are unhistoric'.[1]

Although the story of Peter Blake's disrupted childhood has been told frequently, most recently by Natalie Rudd[2] and Marco Livingstone,[3] it is necessary to recount it briefly here in order the better to understand his work. The work is the man, and the man was the boy who in 1944 joined the ABC Minors Saturday Morning Cinema Club and proudly wore its badge; many years later, in 1961, in one of his most famous self-portraits, he was to depict himself bedecked with a multiplicity of such badges self-consciously clutching Elvis Presley promotional ephemera.[4] Blake the man, who still collects Elvis ephemera, was the boy who, at the age of fifteen, was capable of producing the revealing and technically complex lithograph *Conversation*, and the precociously sophisticated decorated letter, with its sailing ships, skull and cross bones and Baroque flourishes, reminiscent of the witty and erudite drawings of Osbert Lancaster.

Peter Blake was born in Dartford in Kent in 1932, the eldest of three children; his father, Kenneth, was an electrician working for Vickers, though later he was to have his own firm, while Betty, his mother, was a nurse who went on to become a teleprinter operator for Cable and Wireless. With the outbreak of war Peter and his sister, Shirley, were evacuated to Helions Bumpstead in Essex, where they lodged with a Mrs Loft; it was an eccentric household, consisting of herself, a mentally unstable daughter, a son with a fine and enviable collection of comics, a one-legged Boer War veteran, a flatulating farm-labourer, and God – all early recruits to the cast of oddballs who would people much of Blake's future work. He returned to Dartford in 1943, only to be evacuated again the following year when he was sent to stay

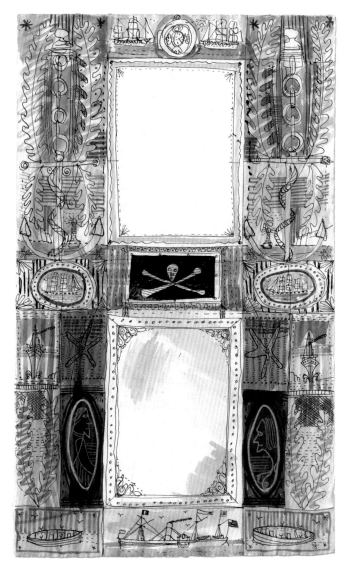

Enid Marx was drafted in to teach for a term at Gravesend School of Art, and encouraged students' interests in popular arts. The unfinished *Thank you letter*, 1948, was intended to be presented to a retired sea captain, a collector of ship's figureheads. Enid Marx kept another of Blake's student drawings until her death.

8

with his grandmother in Worcester; ironically, as he says, he was at home in Kent for the Blitz and the Battle of Britain and in the safety of the country for the quiet times. Both his mother and his grandmother were film addicts who took him to the cinema each week, thus instilling a lifelong devotion to the silver screen, giving him direct access to an escapist world peopled by such heroes as Shirley Temple, Laurel and Hardy, the Bowery Boys and Tarzan. It was these 'fictional' characters who provided stability and comfort to his muddled childhood and would provide models for many of his early paintings. Peter was a solitary boy and the divide between the real world and his private world of imagination and dream was virtually non-existent; later, rendered on paper, canvas or board they were each as real as the other.

In 1945, with the end of the war, he returned to his disrupted schooling in Dartford. Having failed to get into the local Grammar School he was sent to the Junior Art School, which was part of the much larger Gravesend Technical School, an institution geared to the training of artisan craftsmen rather than fine artists. Here, the teaching of practical skills was the prime objective and Peter, along with the other pupils, studied drawing anatomy, typography, Roman lettering, illustration, graphic design, architecture, silversmithing and joinery: a range of qualifications specially devised to equip young men and women for jobs in craft-related workshops and factories, rather than in the fine arts. Although not destined for such work, acquiring these skills was to have a profound and formative effect on Blake's development as both artist and commercial designer. He was fortunate at this early stage in his formal training to have as a teacher Enid Marx, herself a distinguished print-maker and textile designer, who had trained under Paul Nash at the Royal College of Art alongside Edward Bawden and Eric Ravilious. Marx, in collaboration with Margaret Lambert, had just published her groundbreaking book, *English Popular and Traditional Art*, in which she cast the light of her aesthetic eye into such areas as barge painting, fairground art, Valentines, Staffordshire figures and shell grottoes. These 'popular' arts, as they were known, had their roots in what, in the eighteenth century, was described as 'fancy painting'; their subject matter was often whimsical, inspired by dreams, literature, imagination and memory, and they tended to be painted in primary colours.

Such blatantly decorative designs, frequently associated with the bargees, whose colourful craft plied the canals of Britain, could be applied liberally to a wide range of surfaces from chairbacks and mirrors to window-shades and floor coverings.

The grim war years, and the ongoing post-war austerity – rationing did not finally end until 1953 – induced a nostalgia for such time-honoured crafts, which were cheerful and evocative of a simpler and more tranquil age. The qualities Enid Marx particularly singled out as the essence of the 'popular' arts were 'forthrightness, gaiety, delight in bright colours and a sense of a well-balanced design'.[5] All qualities to be associated in the future with Peter Blake's work.

In addition to these traditional arts, popular entertainment – theatre, circuses, cinema, wrestling and boxing matches – were also to prove a rich source of inspiration for Peter Blake's work, in which, to the discomfort of his critics, he has steadfastly refused to make any distinction between 'fine' and 'popular' (artisanal) art. Billboards and posters with colourfully printed lettering, often in quirky or out-moded typefaces, or flowery hand-lettering, intended to catch the eye and advertise the stars as well as the most salacious details of the forthcoming event, made a lasting impression on him as a teenager. Lettering already featured prominently in his earliest exercises in lithography, *Conversation* and *Fairground Boxing Booth*, both executed when he was in his mid-teens, give a foretaste of the power that the image of the printed letter was to exert on him over the years.

Enid Marx, recognising Blake's talent, asked him to draw an illustrated letter, which was intended as a 'thank-you' to a local sea captain, who had allowed her to bring the students to inspect his impressive collection of ships' figureheads; the letter never got written, so the drawing remains to this day in the artist's possession. Although Marx undoubtedly encouraged and broadened his interests, Blake had already discovered a gold mine of discarded curios in a junkyard beside Gravesend Railway Station. Here, out of his pocket-money, he was able to lay the foundations of the cabinet of curiosities that has not only been an ongoing source of visual stimulation, but has become an important aspect of his life's work. He has perfected assemblage as a creative activity

★ ♥ ★

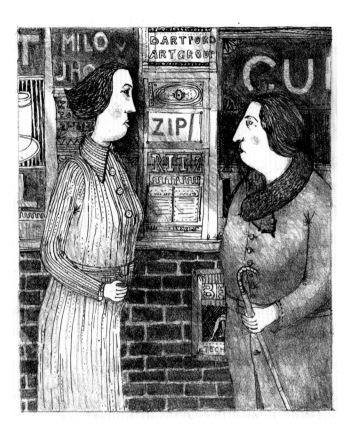

In *Conversation*, one of Peter Blake's earliest lithographs printed at Gravesend School of Art in 1948, the posters and signs between the two housewives make a visual discussion.

in its own right and, as he told Andrew Lambirth, curator of his 1999 Morley College exhibition, 'A Cabinet of Curiosities', regards collecting as being just as much a tool of his trade as pencil, brush and paint.[6]

Trauma struck in 1949 when, as a seventeen year-old, Blake had a serious bicycling accident, leaving him permanently scarred and minus several teeth. The wartime disruption of his childhood and schooling had already led to him being a rather withdrawn, solitary and naturally shy boy; now this added awareness of false teeth and facial disfigurement resulted in him becoming even more self-conscious and introverted. The world of make-believe – the cinema, strip-cartoons and comics – took on a new reality, shielding him from the imagined taunts of his peers, while, at the same time spurring him on to prove that disfigurement was no barrier to success.

His teachers at Gravesend were impressed by such works as his poster design for Lord George Sanger's Circus, and recognised his talent, but could not envisage where it was to lead; in the circumstances, while encouraging his application to the Royal College of Art, they steered his submission towards commercial art and graphic design. By happy chance Blake decided to include a small oil portrait of his sister, Shirley, with the submission he took to the interview. This was an inspired move which was to have a dramatic affect on the course of his career. The portrait attracted the attention of Sir Robin Darwin, the College's Principal, with the result that he was admitted directly to the Painting School rather than the Design School to which he had previously been assigned. However, before he could begin, he was called up for military service, so his entry to the College was deferred for two years, during which time he served as a teleprinter operator in the RAF. He finally enrolled at the Royal College of Art in 1953 and found himself among a convivial group of students including Joe Tilson, Frank Auerbach, Leon Kossoff and Richard Smith, with Ruskin Spear, John Minton and Carel Weight for tutors.

For Blake, as for all young conscripts, many of whom had never been away from home before, National Service was a shock. In the armed-forces, with their barrack-room life, there was no

such thing as privacy, every waking moment had, perforce, to be shared with comrades and room-mates: one's bed-space and locker were the only semi-private things, and even these were subject to regular inspections. Pin-ups and photographs were permitted on the inside of locker doors and Peter, due to force of circumstances, created in his locker what was to be the precursor of many later private shrines – in this case an ephemeral gallery of teenage idols and pop-stars. This provided a creative outlet for his urge to collect and assemble images, while at the same time anticipating an idiosyncratic art form to which he would give greater permanency in later years; an art form that was both personal and voyeuristic: a peep into a private world.

Much of Blake's work has the ability to make the viewer feel like a voyeur; *Babe Rainbow*, the subject of his 1968 enamelled lithograph tin multiple, is viewed as through a keyhole, as are Babe's twins, Bobbie and Billy. Other Blake images such as the dust jackets for *Anthony and Cleopatra* in the Arden Shakespeare series and Roger McGough's *Summer with Monica* also have the power to evoke this feeling of trespass or prying, a sensation at once pleasurable but tainted with an awareness of wrongdoing, as though surreptitiously reading someone else's letters or peeking uninvited into their photograph albums. The combination of pleasure mixed with guilt is heightened by the realisation that the viewer/voyeur may be caught in the act at any moment. This has something to do with Blake's uncanny ability to make public what is private while, at the same time, making private what is public. His poster for the 1975 Summer Exhibition at the Royal Academy, which unashamedly owes a debt to Frith's famous 1881 painting *A Private View at the Royal Academy*, with its portraits of Oscar Wilde, Gladstone, Ellen Terry, John Tenniel, and Frith himself, again has, in direct contrast to the Frith, the ability to make the viewer an interloper, a looker-in rather than a participant. In 1956, the year Peter left the Royal College of Art, the lyrical landscape artist, Ivon Hitchens, wrote an article in *Ark*, the College's magazine, relating paintings to music, and said that his own pictures were painted to be 'listened to'. If Blake had followed Hitchens's dictum the cacophony emanating from *The Royal Academy* would be a discordant jeering and mockery, rising to a nightmarish crescendo. To a lesser extent the same is true of his seminal 1984 record-sleeve for Band

Peter Blake became a full-time student at Gravesend School
of Art in 1949. *Lord George Sanger's Circus* was set as a poster
design project. His human-faced lions and tigers, reminiscent
of Edward Bawden's cats and Ben Shahn's 1930s American
Depression paintings, show influences from two of his heroes.

Aid's *Do They Know It's Christmas?* which purveys a disturbing sense of something uncanny and other-worldly, reminiscent of Henry James's *The Turn of the Screw*.

One of the defining features that distinguishes Blake's commercial work from his fine art is that commercial work is done to order and gets finished to meet deadlines, while his paintings can, in some cases, take years to evolve, being slowly and steadily refined. *Tarzan and his Family at the Roxy Cinema, New York* took thirty-eight years to reach completion, having been started in 1964 and finished in 2002. By contrast, although he had designed record-sleeves previously (most famously for *Sgt. Pepper*), Bob Geldof's 1984 *Do They Know It's Christmas?* put Blake under a degree of pressure in regard to meeting the deadline that he had seldom had to face before. An emotional Geldof, distressed by the weekend television coverage of the Ethiopian famine, telephoned Peter one Monday in November to tell him that he planned to make a fund-raising record for immediate release, and asked him to design the sleeve. Speed was of the essence and Peter's solution to this problem was to have a lasting effect on his working methods and influenced many later commissions. With scissors in hand, he ransacked a stash of magazines, old and new, as well as a cache of Victorian paper cut-out figures originally designed for use on Christmas crackers and home-made cards, and by the simple medium of cut-and-paste, the vivacious, if disturbing, collage, embracing and contrasting bourgeois opulence with fly-ridden African poverty, was completed by the end of the week and the record was in the shops within a fortnight.

As a student Blake had made a series of small collages out of coloured foil, inspired by Mark Rothko and the Colour Field painters, and had long appreciated the potential of the medium for creating bizarre and offbeat imagery. He had used collage for his first commissioned design for *Vogue* and, during the intervening years, regularly exploited a combination of collage and painting in his art. However, in the wake of *Do They Know It's Christmas?* he discovered a fresh enjoyment in his use of the medium; the immediacy of the process, combined with the adrenaline rush brought on by the urgency of the commission, was liberating and exhilarating. Factors soon to be tested again with even greater

urgency when he was required to produce the Live Aid concert poster, for which the entire process from conception to completed artwork, including sourcing the images and hand-colouring the map, had to be achieved within forty-eight hours. The success of this poster brought about a revolution in Blake's working process.

From his time at Gravesend and his early days at the Royal College Blake had been a meticulous painter of printed ephemera, faithfully and painstakingly replicating lettering, photographs, postcards, sweet-wrappers and magazine-covers for such works as *On the Balcony*; later, he began to incorporate real objects, making assemblages such as *The Toy Shop*, and adopted the notice-board technique, affixing postcards and photographs to create *Couples* and *Love Wall*. The two works for Bob Geldof, however, were among the first to use cut-and-paste in this particular manner in order to create an entire and complex image with a message. As Natalie Rudd has neatly expressed it: 'in his paintings he used oil to capture reality, but [now] in his collages he could use pieces of reality to create magic'.[7]

Blake is both an obsessive and a perfectionist. He has the ability and dexterity to produce drawings, watercolours and paintings of breathtaking detail and finish, a skill which, in the hands of a less rigorous and enquiring person, could easily lapse into mere slickness, but for him mastery of this facility provided yet another of the many useful technical tools at his command, to be used when required. It was, though, through exploitation of this skill that he was able to secure some of his earliest commercial jobs such as drawing portraits for *New Society*, painting cover designs for *The Sunday Times Colour Magazine* – particularly the red-lipped acrylic image of Jean Harlow with her plunging neckline – and, slightly later, *Morgan Le Faythful*, guying American strip-cartoons, for *The Daily Telegraph Magazine*. Comics had held a fascination for Blake since those childhood days in Helions Bumpstead, and in 1960 the Royal College of Art's magazine published one of his own, *Only Sixteen*, a take-off of teenage romantic slush literature.[8]

The discipline at *New Society* required him to attend the magazine's Soho office on the day copy was prepared for the printer, and to draw from a photograph, on the spot, whatever image was

★ ♥ ★

The German-American artist Richard Lindner and legendary comedian Max Miller. Two of the life-size hand-coloured photographic cut-outs made for the Beatles' *Sgt. Pepper's Lonely Hearts Club Band* LP cover. Blake's commission, produced in collaboration with Jann Haworth and photographed by Michael Cooper, includes idols and personalities from lists drawn up by the Beatles, Robert Fraser and Blake.

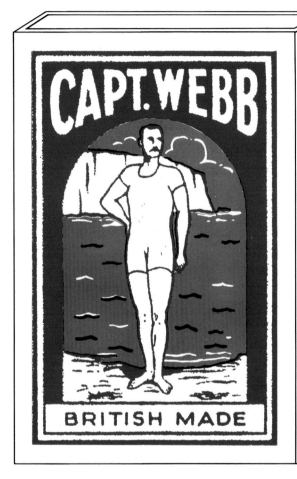

The original three-dimensional painting *Captain Webb Matchbox* c.1960-1, pre-dating Andy Warhol's *Brillo Boxes*, was made of wood and cardboard. In *Motif* magazine (Winter 1962-3) Robert Melville wrote an article 'The Durable Expendables of Peter Blake' for which Blake proposed an accompanying portfolio of lithographs. In the end, the prints were bound into the magazine.

★ ♥ ★

required that week; he sometimes managed to combine this with teaching at St Martin's School of Art round the corner in Charing Cross Road, and recalls that his New Society fee usually got spent in the French House the same evening. Another more complicated challenge at this time was a watercolour group portrait of Tottenham's 1961 double-winning football team for use in a television programme; this had to be done between the triumphal finish of the Saturday match and the Monday evening broadcast. Blake is capable of being both hare and tortoise.

If New Society gave him the confidence and entrée to the world of magazine illustration, it was the birth of The Sunday Times Colour Magazine in 1963 which gave him his biggest break in this field. The specification for The Sunday Times commission, of which he was one of the recipients, was that each of the selected artists were required to choose a place with which they felt an affinity, go there and make a visual record of their responses to it. The commission came soon after Peter's marriage to Jann Haworth, the Slade-trained daughter of a Hollywood art director, and, as she needed to return home to Los Angeles to arrange her affairs, Peter, with his lifelong love of film, and his awareness of the American Pop Art scene, chose California as his dream destination.

Forty-five years later he still recalls the exhilaration of driving along Venice Beach in Ted Haworth's gold Corvette Stingray listening to the Beach Boys. More macabrely he also recalls being taken by his father-in-law on the morning of that fateful day, 22 November 1963, to the warehouse containing the dismantled sets from the Hollywood extravaganza Cleopatra. He spent a very long day locked in this eerie world where, seated on Cleopatra's/ Elizabeth Taylor's daybed, he drew various props and remnants of the dismantled scenery. In the outside world news of President Kennedy's assassination swamped the airwaves, causing Ted Haworth temporarily to forget that he had left his son-in-law incarcerated among the spurious remains of ancient Egypt, while Blake, unaware of this great drama, was acutely conscious of the passing of time. When his father-in-law eventually came to release him, they went to visit another film producer who, to Peter's horror, was drinking champagne in celebration. Marylin Monroe's suicide the previous year, and the linking of her name with that of

Jack Kennedy, was still hot gossip among the movie moguls who inhabited the incestuous world of Hollywood, and there were those among them who rated her loss greater than that of the President.

For Blake the trip to California was the culmination of a dream. The exposure to the hedonistic life, the sunshine and to Hollywood all provided inspiration not only for his drawings which appeared in *The Sunday Times Colour Magazine,* but also gave him the vital injection of first-hand experience of trans-Atlantic pop-culture necessary to lift his work from English parochialism to international status.[9] The language of Pop, which he had been pursuing since his college days, was, after all, for artists and writers of Blake's generation, an international cultural language, although in Britain many people, including the critic Mervyn Levy, perceived it as an 'anti-culture'. Levy, in his *Studio International* article, published shortly after Peter and Jann returned from Los Angeles, wrote: 'the work of Peter Blake is a crystalization of the obsessions, nostalgias, and the sexy-dreamy, sometimes muscle-flexing illusions of admass'.[10] A few years later, at the end of the decade, Peter Evans commented that 'Pop art was not so much the bastard child of commercial imagery and comic strips as a kind of test-tube baby, alive and bouncing, a little harsh, and always suspect. Peter Blake was the man most often named as the father: the English Lichtenstein, the Cockney Rauschenberg'.[11]

In his short, though perceptive, article Levy had said that 'Pinups and boxers are only emblems, and in this sense, pop is a genuine art of the proletariat'.[12] Blake reached the pinnacle of this admass proletarian art with his 1967 cover for the Beatles' *Sgt. Pepper's Lonely Hearts Club Band,* probably the most famous record-sleeve ever likely to be created. The image was instantly raised to the iconic status of such great Victorian paintings as *The Last of England* and *'When did you last see your father?',* which can be parodied in virtually any context in the confident knowledge that the viewer will immediately recognise and appreciate the reference. The work was a joint husband and wife creation, and the story of its commissioning, through the dealer Robert Fraser, with Blake only as a subcontractor, has been repeated many times. It is one of Blake's notable characteristics that from the moment he takes on a commission he has an almost instantaneous vision of how the finished article will

look. Brian Webb, who has worked with him on commissions over a number of years, has always been struck by his extraordinary ability to describe in precise detail the final appearance of a design weeks, or sometimes months, before starting work. When I asked Peter how he developed this knack, he responded by saying that rather than search for complex solutions he nearly always found that the most obvious one was the right one, and therefore it presented itself clearly as a visual image from the beginning.

The set for *Sgt. Pepper* took two weeks to build, and consisted of the zaniest mixture of life-size cut-outs, Jann Haworth's realistic stuffed figures, waxworks from Madame Tussaud's and the Fab Four posed in garish Ruritanian pantomime costumes behind the drum – they appear again stage left as waxworks dressed in dark suits and black ties, like negative images of themselves. It is a crazy but successful blending of two- and three-dimensional imagery. Blake has always had a good working relationship with Madame Tussaud's, and the figure of Sonny Liston on the extreme left of the group now greets visitors to his studio: he stands impassively by, part well-trained servant, part threatening 'heavy', ready to defend his master should things get out of hand. In the 1960s Blake also designed a witty poster for the famous Wax Works advertising their 'Giant', in which a 1920s flapper sits unconcerned, while the other figures, cut from period advertisements, regard the giant's leg with amazement.

In August 1999, through Trickett & Webb, Blake was asked by the Foreign Office to recreate the mood of *Sgt. Pepper* for a poster celebrating 'Britishness', which would be sent to every British embassy and consulate around the world to mark the millennium. He carried out the commission in Trickett & Webb's studio, working not with scissors and paste but with computer-scalpelled cut-outs: this time the Queen, rather than the Beatles, is centre stage, while a cut-out of their waxworks, lifted from the original 1967 sleeve, is immediately behind her. These pivotal figures are surrounded by a disparate cast of characters ranging from Churchill and Quentin Crisp, to Dickens, Margaret Thatcher, Barbara Hepworth and Alfred Hitchcock, with Isaac Newton and John Galliano leaning on a classic British mini. Inspired by this exuberant cast The *Mail on Sunday* ran a competition to see who could identify the greatest number of individuals.

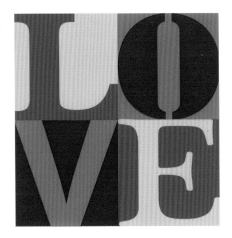

The *LOVE* print, 2008, for the Chelsea Arts
Club, and enamelled metal badges, *Pop Art*,
2006 for Pallant House Gallery, Chichester,
were designed as fundraising limited editions.

Shortly after returning from California Blake was commissioned, along with Leonard Rosoman, Ceri Richards and Frank Bowling, to paint several large mural panels, fifteen feet high and forty feet long, for the Shakespeare quatercentenary exhibition at Stratford, which was being masterminded by the ballet critic and writer, Richard Buckle. These weeks working in company with other painters in Shakespeare's birthplace provided an antidote to the hedonistic world of Hollywood and The Beach Boys, concentrating Blake's attention once again on England and the written word. Over the next few years – particularly after Peter and Jann, along with their young daughter, Liberty, moved out of London to live in a disused railway station at Wellow in Somerset – Puck, Peaseblossom and Mustardseed were gradually superseded by Alice, the Mad Hatter, Tweedle-Dee and Tweedle-Dum and other characters from Lewis Carroll's *Alice Through the Looking Glass*. Blake's vision of Carroll's characters, strongly influenced by Tenniel's original drawings, were realised as both watercolours and screen prints, originally intended for publication in book form as a companion volume to Graham Ovenden's *Alice in Wonderland*. Although this project was never fully realised, four of the watercolours were translated into stained glass, while the garden at Wellow began to be populated by Jann's three-dimensional characters from *Alice*. This idyllic interlude ended when Peter and Jann split up in 1979.

It was during this period at Wellow, and at the time of the formation of the Brotherhood of Ruralists, that Peter attended what he claims was his first auction intending to buy a few reference books. Obliviously unaware that twenty or more books could be lotted together rather than sold as single volumes, he returned home from Bath in a taxi bulging with bound copies of the *Cornhill* magazine and *Larousse*. At first these tomes, along with his ever-growing collection of postcards, provided visual and historic material that could be incorporated into paintings, but later, realising how out-of-date the texts were, they became quarries to be mined ruthlessly with scissors and scalpel.

Visiting Blake in the early autumn of 2009, while he was working on the series of collages, *Aquarium, World Tour, Paris*, etc., for his two Paris exhibitions at FIAC (Le Foire Internationale de l'Art Contemporain) and the Gallerie Claude Bernard, two tables, one

in his studio, the other in his house, were stacked with neat piles of meticulously cut out heads, birds, fishes and butterflies. To the horror of his wife, Chrissy, herself a painter, and their print-maker student daughter, Rose, a confetti-trail of off-cuts, like Hansel and Gretel's breadcrumbs, littered the floor and led from room to room. The multi-layered collages he created for the Paris exhibitions are among the most intricate and complex he has made; some of them, such as *Parade* and *Paris–Chicken Act* being made up of a veritable mosaic of literally hundreds of individually cut out heads and figures. His scrupulous preparation for each of these collages, with the almost clinically neat piles of cut-outs laid out ready like the ingredients for some complex gastronomic tour-de-force, shows Blake at his most obsessive. An obsession that is also reflected in the meticulous filing of his postcards by subject matter. In one of the work-spaces in his studio I counted twenty-four identical boxes of postcards labelled alphabetically from 'Babies, Ballet, Bath and Beatles' to 'Valentines, Villages, Volcanoes, Wales, Waterfalls, Women, Workers' and 'Wrestlers'. There is a separate box devoted exclusively to Marilyn Monroe.

In 1983, on the recommendation of Brian Robertson, Blake worked on a series of costume and set designs for *The Nutcracker* for Covent Garden; sadly, despite his enthusiasm and long preparatory research, these were rejected on the somewhat specious grounds that he did not understand how dancers and actors wore clothes. Sixty years previously Haldane MacFall, in *The Book of Lovat*, noted that Lovat Fraser, 'like most of the designers of stage-dress to-day, had of course learnt much from Bakst, who had by sheer genius, beauty of handling, and the use of exquisite harmonies of colour, raised costume designs into lyrical works of art – leaving the makers of the costume to shape them as best they could... The result was a collection of colour-harmonies that promised great things for the theatre, though they are of course of lesser pictorial value for the walls'.[13] Given Blake's fascination with costume, and the fact that a section of his studio is devoted to old clothes and textiles, the theatre may have missed a visual experience, but at least his remaining studies retain some pictorial value.

Over the years Blake has designed china for Wedgwood, textiles for Stella Macartney, *Pop Art* badges for Chichester's Pallant House

Gallery, advertising material for a clothing firm in Korea, and the carpet for the Supreme Court, but surprisingly, given his craft training at Gravesend, virtually all his design work is paper-based, either drawn or collaged, plus the occasional use of the computer for speedy compilation of the Foreign Office's poster or for type-setting. A recent exception is the carpet for the Supreme Court with its national emblems. Due to the tufting, which reacts to footfall and the sweep of the vacuum-cleaner, thus creating changeable visual effects, an appreciation of the material and the manufacturing process was essential.

A recent discovery for Blake has been gyclée or ink-jet printing. As with collage, he is excited by the immediacy of the image-making process made possible by this new technology, which he has exploited in the production of a series of large prints, particularly of found objects – flags, price labels, etc. – as well as in the preparation of psychedelic lettering for the film *Sex & Drugs & Rock & Roll*, about the life of the pop musician, Ian Dury, whom he had taught at Walthamstow School of Art. The subliminal message of the title being superimposed over a fast-moving, colourful, animated collage of rainbows. The ink-jet printing machine is controlled by computer and for the eye-catching enamelled tinplates *I Love London* and *I Love Recycling*, commissioned by the Creatively Recycled Empire Ltd, various existing classic hallmark Peter Blake imagery was transferred to disc, and by the simple expedient of making fresh juxtapositions and arrangements a new/old Peter Blake Pop Art design was created almost instantly at the press of a button. Nostalgia has always been an important element of Pop Art and, for those of Blake's generation, the sight of these tinplates revives instant memories of the Beach Boys and *Babe Rainbow*: forty years fall away as though they had never been. These tinplates are not just nostalgia, they are vibrant, early twenty-first-century, artefacts in their own right. Both Peter Blake and Pop Art are alive and well and capable of reinventing themselves.

Blake, now aged seventy-seven, is working harder than ever. Having finished the hundred and twenty or so collages for his Paris dealer, Claude Bernard, he is looking forward to tackling a poster for Green & Black's chocolates incorporating the fifteen different colours of their wrappings, five cover designs for

★ 🖤 ★

Penguin Books, including *Lucky Jim* and *Billy Liar*, a design for *Oliver Twist* for Puffin Books, as well as making jewellery. The jewellery – necklaces principally – are 'votive offerings' intended more for display than for wearing, consisting of one-off assemblages of sympathetically selected objects – ivory elephants, Byzantine crosses, items from a doll's make-up set. The idea is clear in his mind and the ingredients are gradually being amassed; when he is ready he will do the final lay-out before passing them over to a skilled technician to carry out the soldering and other processes, in much the same way as he created the bronze equestrian groups for Blackpool's Golden Mile. Blake, both through painting and assemblage, has devoted his life to transforming everyday objects into works of art; for him art is like magic and 'is more about looking than explaining'.[14]

Between all these projects, and fresh ones which seem to come in on a weekly basis, he steadily continues to work on, and will one day bring to completion, the one hundred and sixty or so illustrations for Dylan Thomas's *Under Milk Wood*, which he started many years ago. Obsessive would again be an understatement to describe this ongoing project; every single one of the illustrations is started, and many are finished. Most are pencil drawings of a fineness that is hard to believe, with their gently nuanced shading and modulation they look like the most perfect gelatine prints; others are in watercolour or collage, while some are worked over his own photographs taken at Laugharne. Like *Tarzan and his Family at the Roxy Cinema*, it is the elaboration of detail required to bring the conception to realisation that takes the time, not the conception itself; he is clear in his own mind as to precisely what needs to be done to each of the unfinished illustrations, and he lovingly returns to them week after week, month after month.

Blake makes little or no distinction between 'art' and 'design'; throughout his career, which now stretches back more than half a century, he has ploughed his own course with integrity, and stamped his vision and personality on these decades. His links with American Pop Art are felicitous. His visits to California in the early 1960s, and later to visit David Hockney, ensured that he had a first-hand knowledge of the work of Jasper Johns, Ed Ruscha, Robert Rauschenberg, Elsworth Kelly, and others. The fact that

★ ♥ ★

flags, lettering and other devices are a common linking feature is fortuitous. Blake is an uniquely English figure, content to be rooted deeply in the soils, and tarmac, of Kent, South Kensington and Chiswick, but aware and happy that others across the globe are following similar paths. Over the years he has had to fight his corner against mockery, accusations of derivativeness, irrelevance and being out of touch with contemporary trends, and yet, more than many of his widely esteemed contemporaries, he has set out his own achievements in the way Jan Tschichold, the Bauhaus-inspired typographer, advocated in the quote I used at the head of this essay. His work – just look at *Babe Rainbow* or *I Love Recycling* – though unhistoric is firmly rooted in the popular culture of his time and has already become classic: it is an enduring, and endearing, part of British visual culture of the last fifty years.

1 Jan Tschichold, *The New Typography*, translated by Ruari Mclean, University of California Press, 1995, p.65. (Originally published, Berlin 1932, revised 1967, republished Berlin 1987).
2 Natalie Rudd, *Peter Blake*, London: Tate Publishing, 2003.
3 Marco Livingstone, *Peter Blake: One Man Show*, London: Lund Humphries, 2009.
4 *Self-Portrait with Badges*, 1961, Tate.
5 Enid Marx and Margaret Lambert, *English Popular and Traditional Art*, London: Collins, 1946, p.8.
6 Andrew Lambirth, *A Cabinet of Curiosities from the Collection of Peter Blake*, Catalogue to the exhibition at Morley College, 1999, p.9.
7 Ibid, p.15.
8 *Ark*, No.25, Spring, 1960.
9 Blake's drawing were published in *The Sunday Times Colour Magazine*, 15 November, 1964.
10 *Studio International*, November 1963, p.189.
11 David Bailey & Peter Evans, *Goodbye Baby and Amen: A Saraband for the Sixties*.
12 *Studio International*, op. cit.
13 Haldane MacFall, *The Book of Lovat*, London: J.M. Dent, 1923, p.160.
14 Andrew Lambirth, Introduction to *A Cabinet of Curiosities*, op. cit.

A one-off watercolour and collage poster, 1955,
for a Royal College of Art Common Room party.

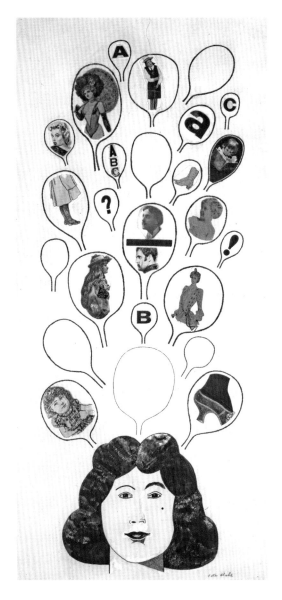

Rejected illustration artwork in ink and collage
commissioned by *Vogue* in the mid-1950s.

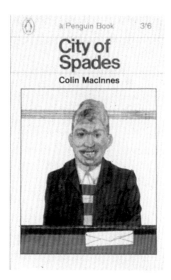
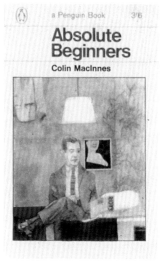
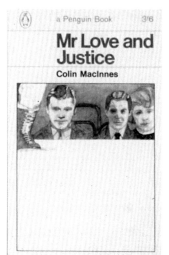
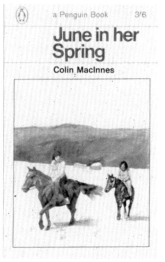

Penguin covers, 1961-1964, for a series of Colin MacInnes novels.

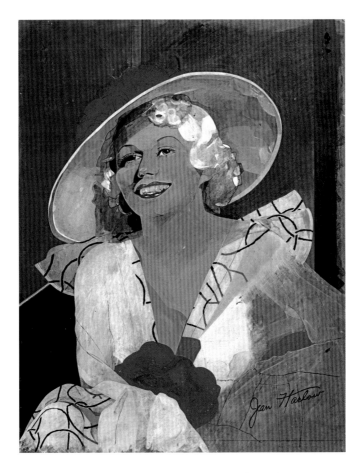

Acrylic portrait of Jean Harlow. Commissioned
with a two-week deadline as a cover design by
The Sunday Times Colour Magazine, 1964.

In his editorial to *Motif* 10, (Winter 1962-3) Reyner Banham wrote that 'physical and symbolic consumability are equal in Pop Culture'. Blake exemplifies this in his elevation of ephemera into lithographs created for the magazine. *Motif's* editor Robert Melville illustrated Peter Blake's painted postcards and placards, pin-ups and girlie doors, demonstrating his precocious maturity.

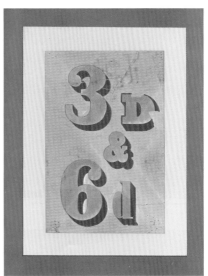

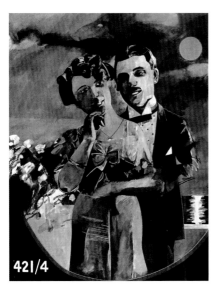

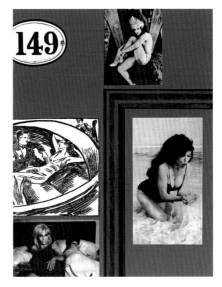

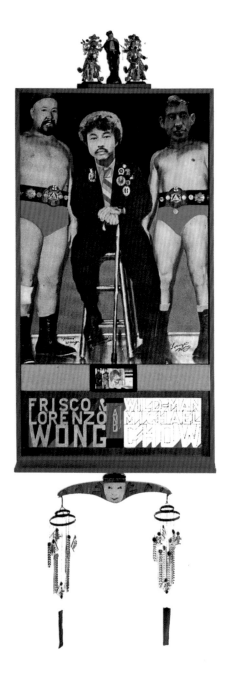

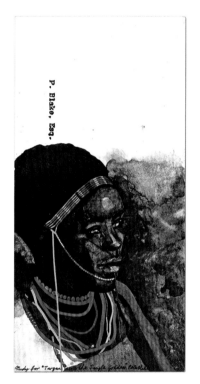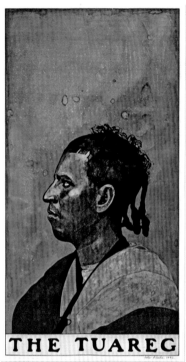

Opposite, Frisco and Lorenzo Wong and Wild-Man Michael Chow, 1966, printed as a promotional postcard for Chow's Mayfair restaurant Game. *Above left*, a souvenir postcard for Blake's dealer Robert Fraser, 1965-6, and *above right, The Tuareg*, watercolour, 1972. from a set of six watercolours of imaginary wrestlers corresponding to national types produced as limited edition screen prints.

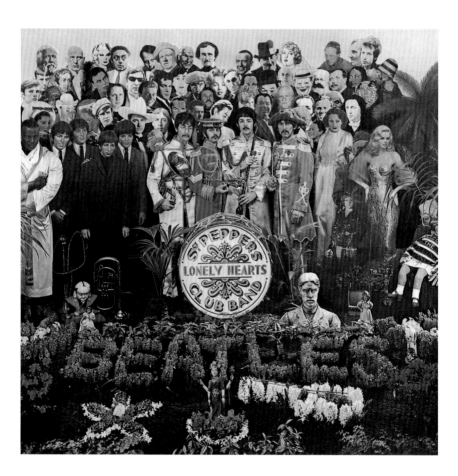

In 1967 Paul McCartney commissioned Peter Blake's
London art dealer Robert Fraser to suggest an artist
to design the sleeve for a double album. When *Sgt.
Pepper* was issued as only one disc the second
sleeve became the *Sgt. Pepper Cut-Outs* insert.

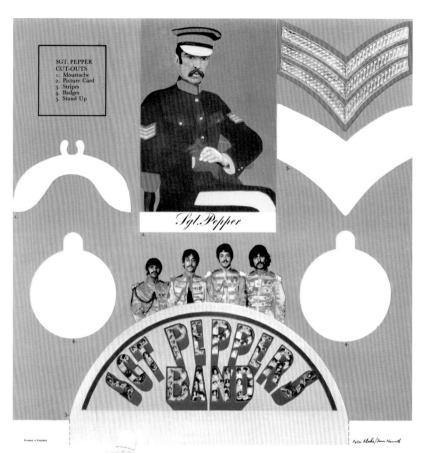

SGT. PEPPER
CUT-OUTS
1. Moustache
2. Picture Card
3. Stripes
4. Badges
5. Stand Up

Sgt.Pepper

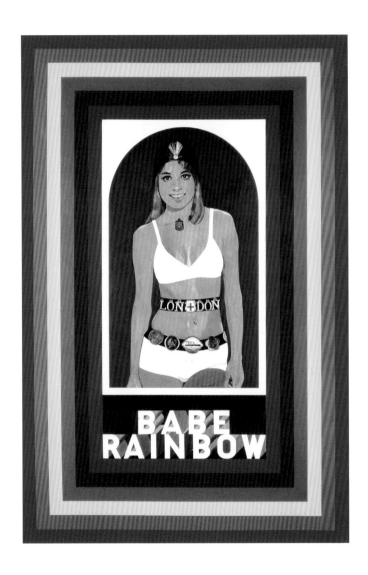

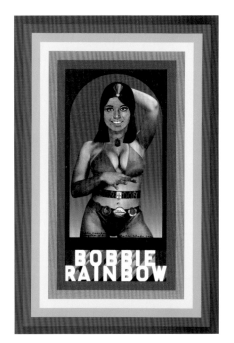 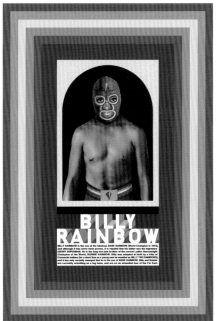

Babe Rainbow, 1968, lithograph on tin, printed in an edition of 10,000 commissioned by Dodo Designs and retailing at £1. Babe Rainbow, a wrestler from New Cross, was the daughter of the fictional Doktor K. Tortur. Her features, apart from the broken nose, were derived from a *Marie Claire* cover model. *Bobbie Rainbow*, her daughter, appeared 35 years later, as another tinplate edition commissioned by Pallant House Gallery, Chichester. More recently, *Billy Rainbow*, Bobbie's gay twin brother, appeared as a limited edition print on paper.

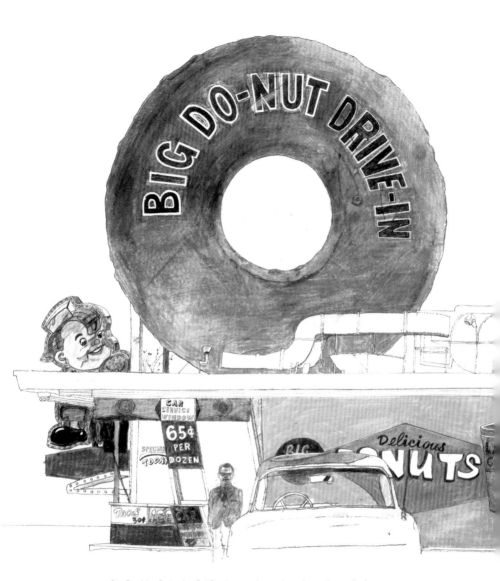

Big Do-Nut Drive-In, California was drawn in coloured pencils from
the driver's seat of his father-in-law, Ted Haworth's, gold Corvette
Stingray and appeared under the title 'Peter Blake in Hollywood' in
the 15 November, 1964 issue of *The Sunday Times Colour Magazine*,
commissioned by David Sylvester and Mark Boxer.

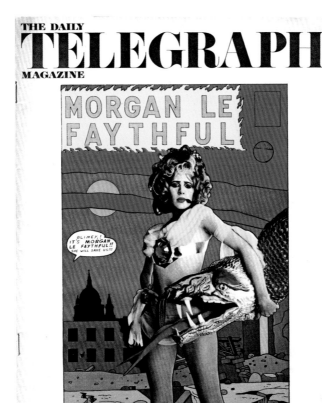

The Daily Telegraph Magazine commissioned Blake to design a 'special offer' poster to accompany an article 'Posters: Big Business or Art?' Appearing over Easter weekend 1968, Blake's blatantly secular image of Marianne Faithfull with a Jann Haworth monster provoked an outcry. Signed 'Pete Blake' in mock homage to the professional comic strip artists.

HAVE YOU SEEN OUR GIANT?

MADAME TUSSAUD'S
Baker Street TODAY 10 – 5·30

Peter Blake Dec 1968

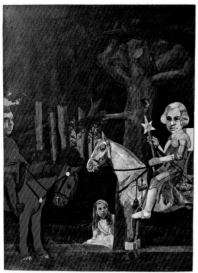

and the two Knights sat and looked at each other for some time without speaking. Peter Blake 1970/71.

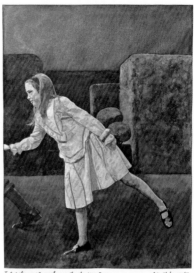

Just at this moment, somehow or other, they began to run. Peter Blake 1970/71.

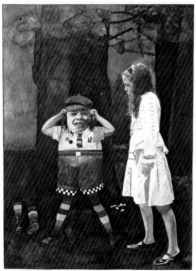

"But it isn't old!" Tweedledum cried, in a greater fury than ever." It's new, I tell you - I bought it yesterday - my nice NEW RATTLE!" and his voice rose to a perfect scream.

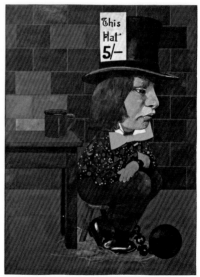

"For instance, now, there's the King's Messenger. He's in prison now, being punished: and the trial doesn't even begin till next Wednesday: and of course the crime comes last of all." Peter Blake. 1970.

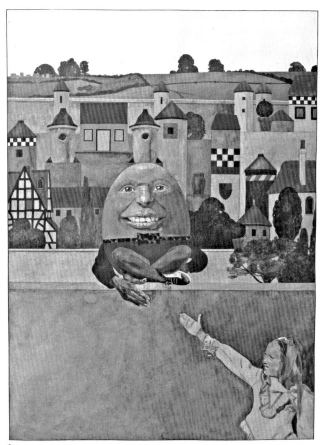

"and to show you I'm not proud, you may shake hands with me!" Peter Blake.1970/71.

Planned as a companion volume to Graham Ovenden's
Alice in Wonderland, Peter Blake's *Alice Through the
Looking Glass* was originally intended to be published in
1972 to celebrate the centenary of the first publication
of Lewis Carroll's masterpiece. Blake's watercolours
were published as limited edition screen prints, and
in 2006 finally published in book form.

With Blake's lifelong interest in incorporating images from popular culture into his 'fine art' he was a natural for reversing the process, turning fine art back into images for hoardings and advertising.

Royal Academy 207th Summer Exhibition of Contemporary Paintings, Engravings, Sculpture and Architecture

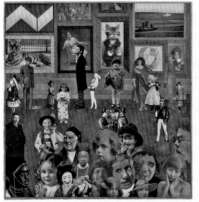

3 May to 27 July, 1975
Admission 60p. Mondays 3
Weekdays 10 to 6 Sundays

THE 10th LONDON TO BRIGHTON BIKE RIDE

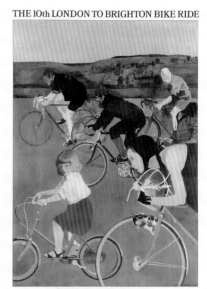

SUNDAY, JUNE 30th, 1985

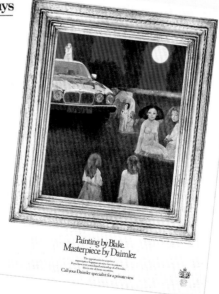

Painting by Blake.
Masterpiece by Daimler.

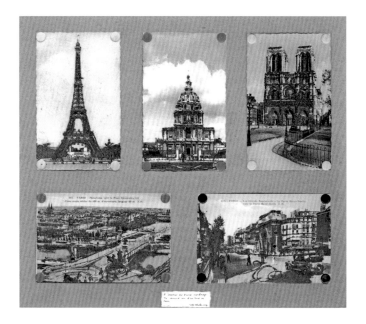

During the late 1960s and 1970s Blake created a series of tributes as gifts for various friends. *Images of Paris* for David Hockney, and *Mr Kyte* from the closing track from side one of *Sgt. Pepper* for John Lennon. Despite taking this to New York, Blake was unable to deliver it due to the high security surrounding Lennon.

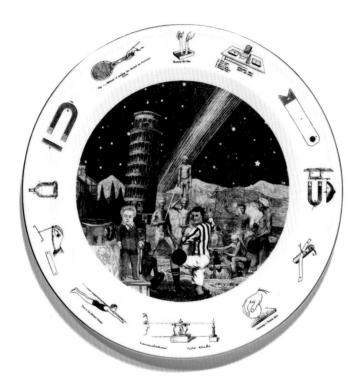

Demonstrations. Limited edition plate commissioned by the National Art Collections Fund and produced by Wedgwood, 1992. Other plates in the series were designed by John Piper, Patrick Caulfield, Patrick Heron, Bruce McLean and Eduardo Paolozzi.

"...our love will be an epic film with dancing songs and laughter". (left)

"...and scattered like memories old and worn the litter has inherited the dawn." (right)

Pen and ink illustrations and watercolour cover for Roger McGough's 1978 poem *Summer with Monika*.

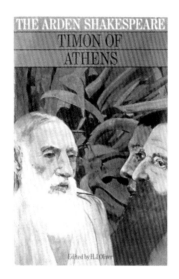
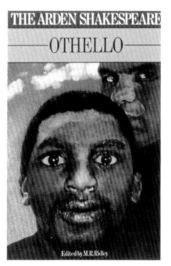

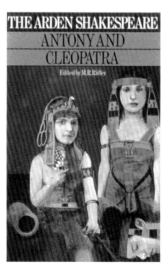

Commissioned in his Brotherhood of Ruralists period, Peter Blake's watercolour cover designs for the Arden Shakespeare, 1969.

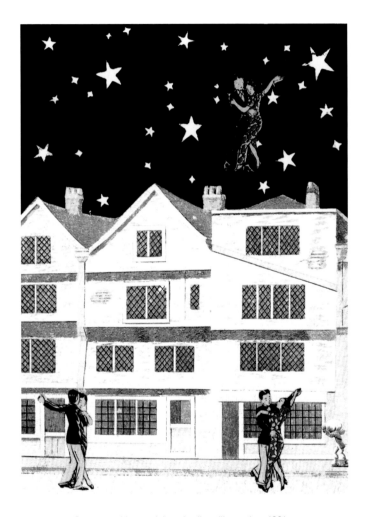

Dancing to Heaven, ink and collage illustration, 1991.

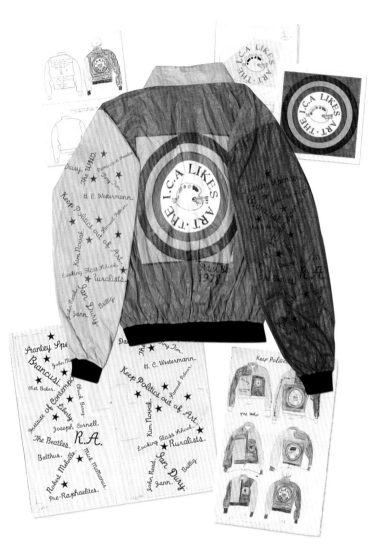

Peter Blake, Allen Jones and Patrick Caulfield all designed paper jackets to be sold to raise funds for the Institute of Contemporary Arts, 1978.

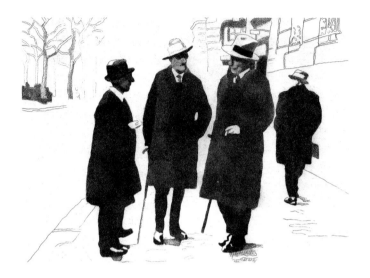

In 1983 Blake's print publisher Alan Cristea commissioned a
portfolio of etchings and sent him to Paris to work with the master
printer Aldo Crommelynck, who taught him the rudiments of the
process. Blake chose as his subject matter *James Joyce in Paris* and
made nine images inspired in part by Gisele Freund's photographs
in the book of the same title, which she had co-authored with
V.B. Carleton. *Opposite,* young Joyce. *Above,* the conversation is
between James Stephens, Joyce and John Sullivan.

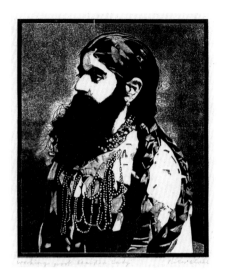

working proof 'Bearded Lady' Peter Blake

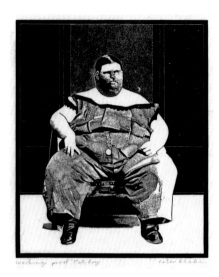

working proof 'Fat Boy' Peter Blake

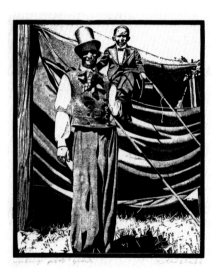

working proof 'Giant' Peter Blake

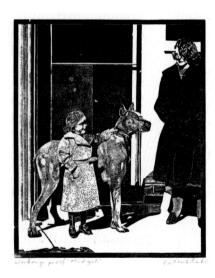

working proof 'Midget' Peter Blake

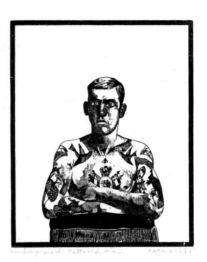

Blake's twin obsessions with technical excellence and offbeat popular entertainment imagery reached its peak in *Side Show*, a set of five exquisite wood engravings (1974-8) *Bearded Lady, Fat Boy, Giant, Midget* and *Tattooed Man*, published by Waddington Graphics.

DROSSELMEYER

In 1983, at the suggestion of Brian Robertson, Director of the Whitechapel Art Gallery, Blake was commissioned to design a production of Tchaikovsky's *Nutcracker Suite* for the Royal Opera House, Covent Garden. Despite considerable historical research Blake's witty and lively designs were rejected on the pretext that he didn't understand design for the stage. Designs by Julia Trevelyan Oman were used instead.

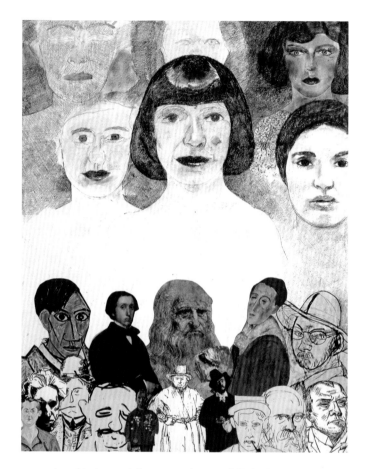

An original artwork for a poster *Artists and Models* illustrates
Blake's fondness for groups. It follows on from *Sgt. Pepper* and
uses combinations of paint and collaged material. The lower
group of artists includes Picasso, Leonardo, Modigliani, and in
the foreground Blake's *Self Portrait with Badges*.

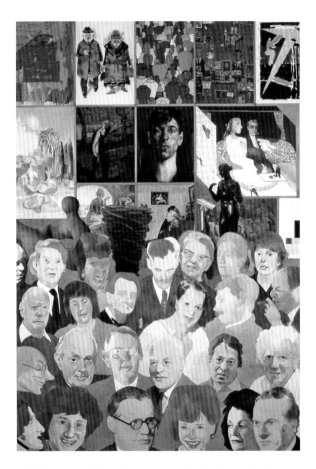

Original artwork for a Contemporary Art Society poster *Patrons*, including founder member Lady Ottoline Morell at bottom left, and works by Spencer, Sickert, Bacon, Hockney, Moore and Blake's own *On the Balcony*, which the Contemporary Art Society had purchased and donated to public galleries.

Tourist Attractions. The grand tour of illustration, six collages which originally appeared as the cover illustration and section dividers for the fourteenth edition of *European Illustration* designed by Trickett & Webb, and published by Booth Clibborn Editions, 1987.

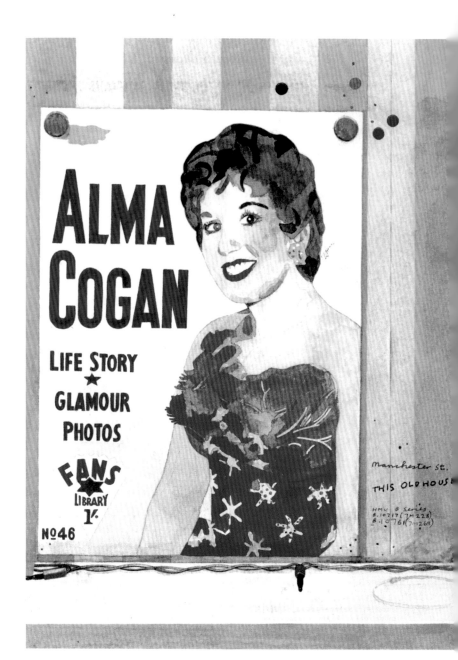

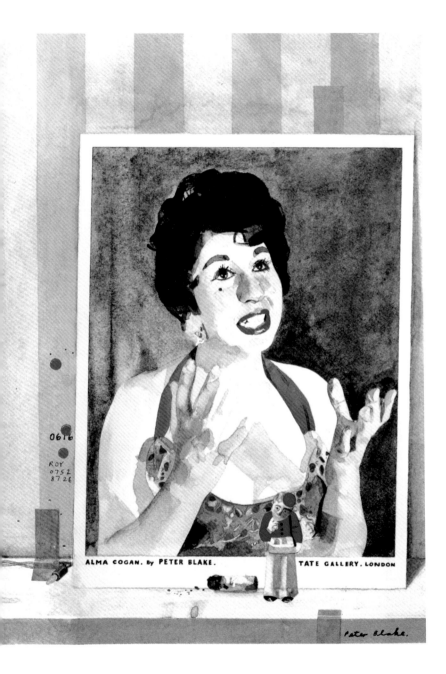

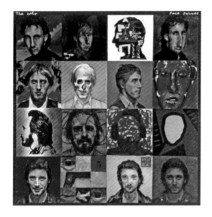

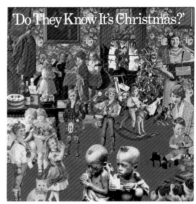

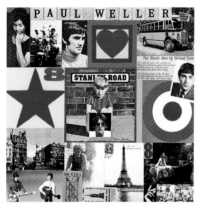

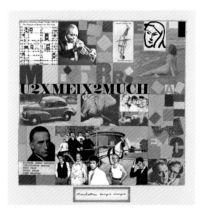

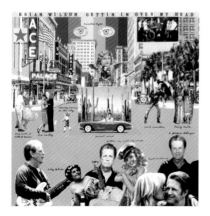

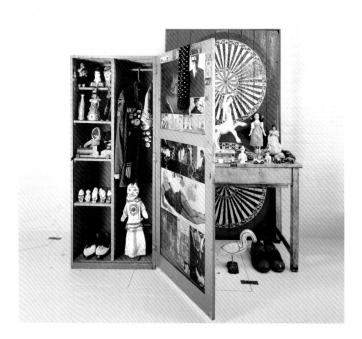

Opposite, six record sleeves. From top left: The Who, *Face Dances,* 1981; *Do They Know It's Christmas?,* 1989; Paul Weller, *Stanley Road,* 1995; Landscape, *Manhattan Boogie-Woogie,* 1982; Brian Wilson, *Gettin' in over my Head,* 2004; and John Peel, *Right Time Wrong Speed,* 2006. *Above,* Oasis, *Stop the Clocks,* 2006. The first thought for the design of the sleeve was to base it on the shop front of the 1960s King's Road shop Granny Takes a Trip. Due to unforeseen circumstances this was not possible. Instead Noel Gallagher selected items from the studio placing many of them on the shelves of Blake's iconic 1959 *Locker,* thereby creating a non-existent mythology.

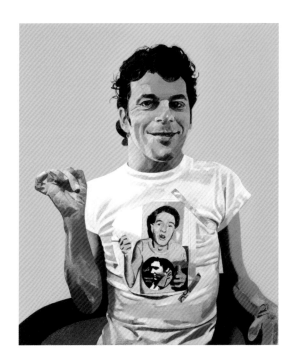

A former pupil of Blake's at Walthamstow School of Art,
2001, painted from photographs shortly after Dury's death
and used as the cover image of the album *Brand New Boots
and Panties: Tribute to Ian Dury*. *Opposite*, collage print *Yellow*,
commissioned by Yellow Pages.

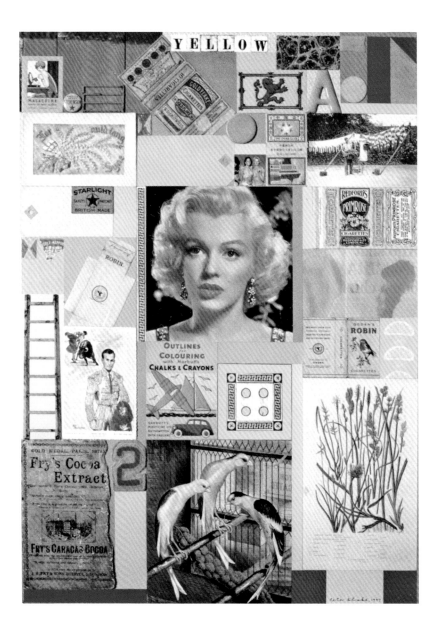

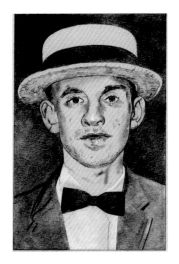
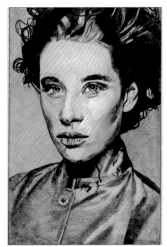

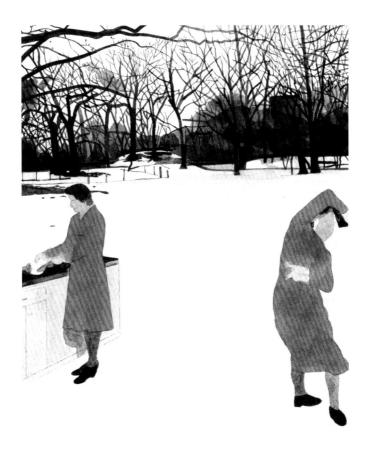

Work in progress illustrations for *Under Milk Wood*, an ongoing project depicting the scenes and locations as well as every character and dream in Dylan Thomas's Welsh saga. The dreams are in watercolour, the character portraits in pencil and the scenes in collage, some incorporating photographs taken by Blake at Laugharne in the 1970s.

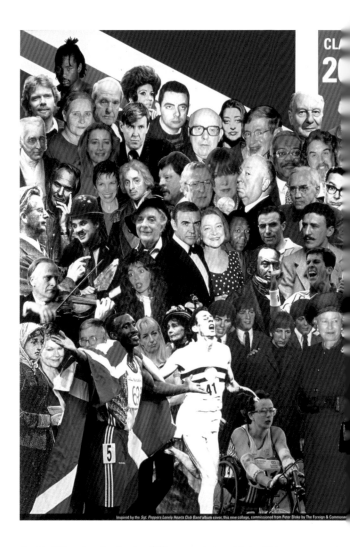

Inspired by the *Sgt. Peppers Lonely Hearts Club Band* album cover, this new collage, commissioned from Peter Blake by The Foreign & Commonwe

For the Millennium the Foreign Office commissioned Peter Blake and Trickett & Webb to 'create a *Sgt. Pepper* for the next century' poster to be distributed to every British Embassy and Consulate around the world. Working 'over the shoulder' in Trickett & Webb's

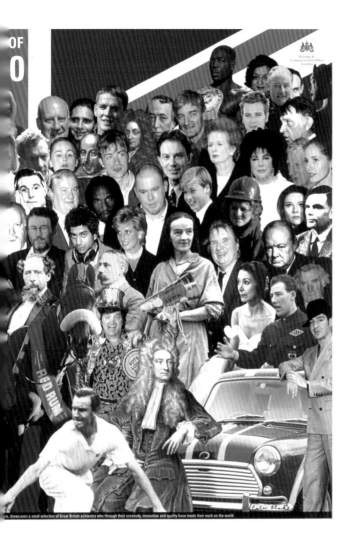

studio, the selection of personalities in art, science and public
life in the 20th and 21st centuries was left to Blake and Trickett
& Webb and assembled on a computer screen, a technique
which Blake has continued to use and develop.

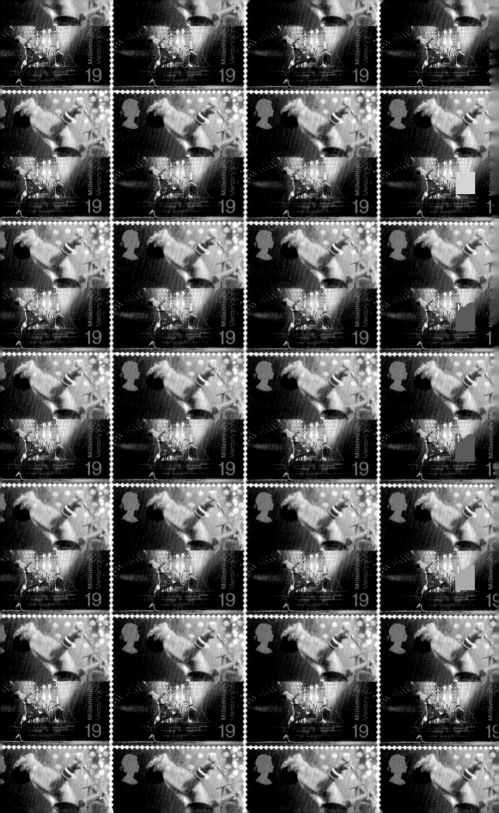

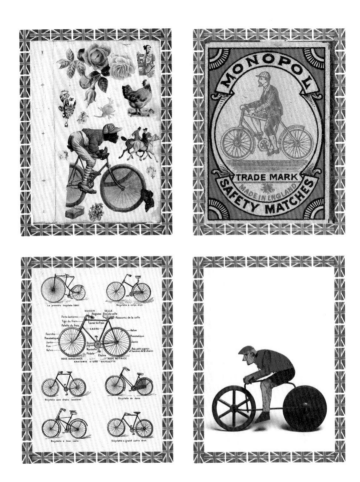

Opposite, Millennium postage stamp *Popular Music,* 1999, from *The Entertainers Tale,* featuring Freddie Mercury at the Wembley Stadium Live Aid Concert. Mercury, an avid stamp collector, bequeathed his collection to the British Postal Museum. *Above, There and Back Again,* a portfolio of cycling images derived from advertisements, matchbox labels and toys, commissioned by Samsung to promote their clothing brand Bean Pole in South Korea.

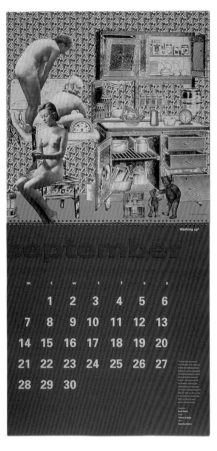

Over a period of years Trickett & Webb collaborated with the
screen printer Augustus Martin and artist friends to produce
a series of technically challenging calendar images. Each year
a provocative theme was proposed and the twelve selected
artists were free to interpret their chosen subject. From left to

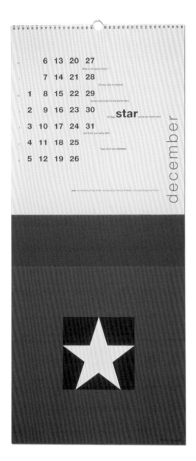

right: *Old Boy* (for Oxymoron), *Washing Up* (I Am a Doughnut, international misunderstanding – triggered by President Kennedy's famous 'Ich ein Berliner' speech), *Lucky Star* (Touch Wood) and *Half a Double Elephant*, a pre-International Standard paper size for a calendar of technical terms and private languages.

Short-lived crazes and the long-lived Volkswagen Golf, 2002.

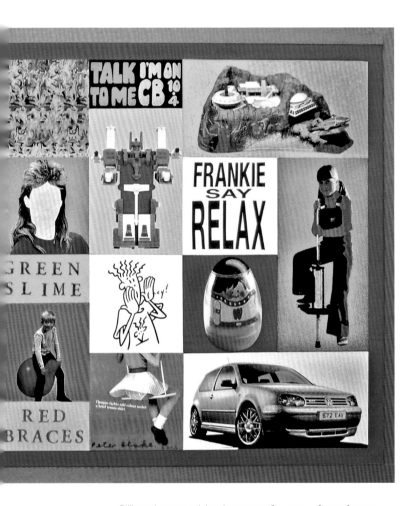

Billboard poster celebrating twenty-five years of manufacture.

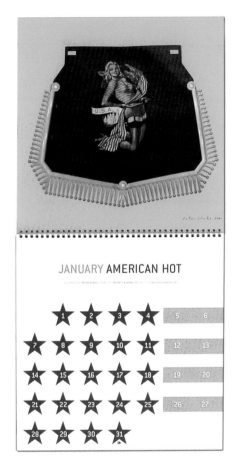
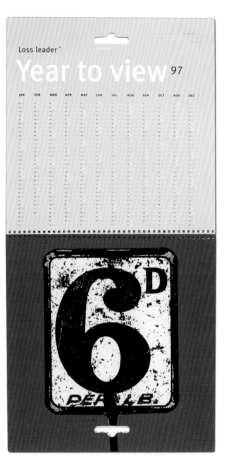

More calendar favourites *American Hot*, a pin-up on a motor scooter mud flap (Pizza to Go); *Loss Leader* (Counter Culture).

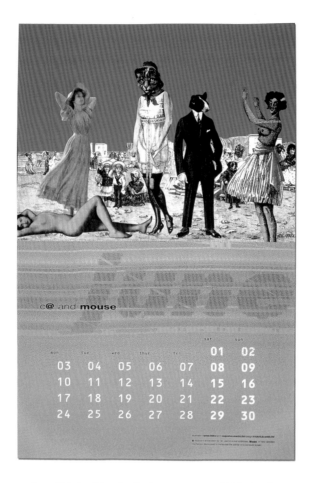

Peter Blake's subject for the Internet-not yet, 1990 calendar
is *Cat and* (computer) *mouse*. The collage characters meet
on an international beach.

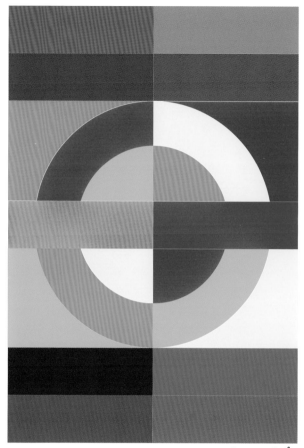

Peter Blake

Opposite, tufted carpet incorporating the national emblems, 2009, manufactured by Wilton Royal Carpet factory for the Supreme Court of Justice housed in the old Middlesex Town Hall, Parliament Square. *Above*, Blake's contribution to a multi-artist, multi-image poster series, 2009, *Art on the Underground*. The concept of recreating the Underground barred circle logo as a geometric abstract in the manner of Sonia Delaunay, is truly original and exemplifies Blake's strongly held belief that the obvious is frequently the best

Homage to the Kurt Schwitters, 2008. Collages in recognition of the 20th Century Dadaist. *Opposite*, A and Z, from *Alphabet*. Having been interested in lettering and letter forms since his early student days, (his 'craft' at art school was 'Roman Lettering'), it was almost inevitable that one day he would create his own alphabet.

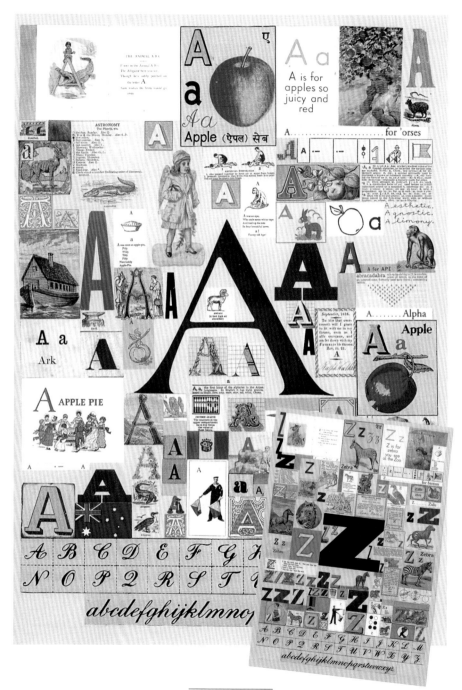

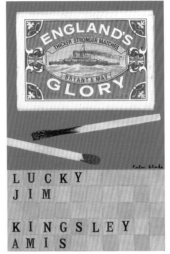

MEMENTO
MORI

MURIEL
SPARK

LUCKY
JIM

KINGSLEY
AMIS

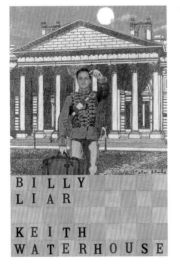

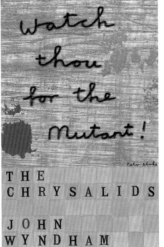

BILLY
LIAR

KEITH
WATERHOUSE

THE
CHRYSALIDS

JOHN
WYNDHAM

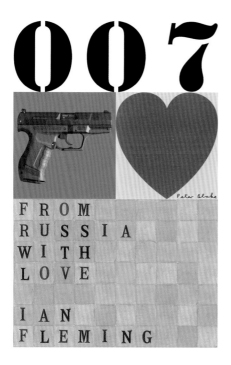
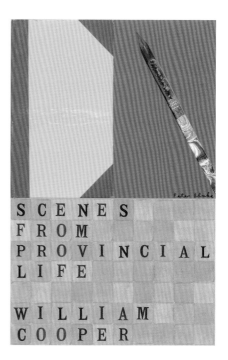

Artworks for Penguin Classics titles, 2010, to celebrate the seventy-fifth anniversary of Penguin Books. These 1950s titles are assembled from Peter Blake's favourite 'found lettering' Victorian childrens' spelling tiles.

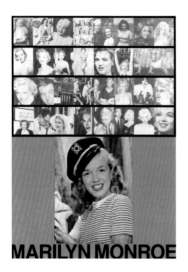

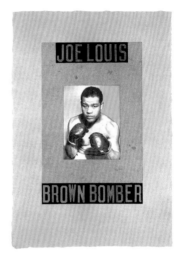

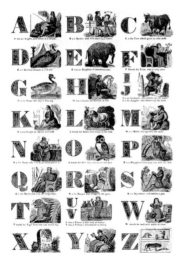

M is for Marilyn and *Monroe*… An alphabet in pictures published as limited edition screen prints, 1991, by Waddington Graphics.

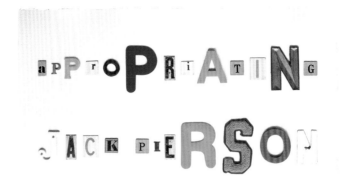

Blake's interest in lettering led him to create *Appropriating Jack Pierson,* an exhibition in 2002 returning the compliment to the American artist who transforms found commercial signs into artworks and who acknowledges Blake as an influence. On being told of plans for the exhibition, Pierson's comment was 'spooky'. The exhibition in New York was Blake's first in forty-six years; having refused to show again in the United States after New York critics accused him of 'appropriating' American Pop Art.

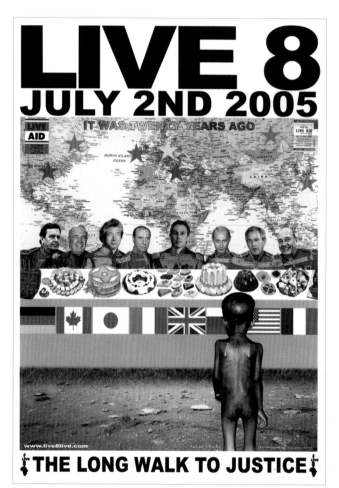

The 2005 poster for the 20th anniversary Live Aid concert. *Left*, a unique collecting box for the World Wildlife Fund. One of a series specially commissioned from a number of eminent artists auctioned in aid of the Fund. Given Blake's interest in wrestling he 'assumed' that WWF stood for World Wrestling Federation and turned the collecting box into a sumo-panda.

An as yet unused image, *above*, and beer bottle labels for Cain's Brewery, Liverpool, to celebrate the award of European City of Culture, 2008.

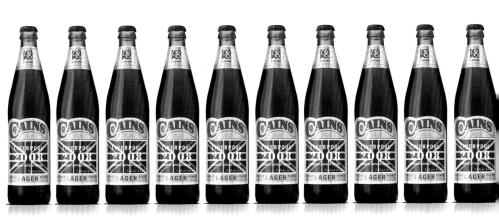

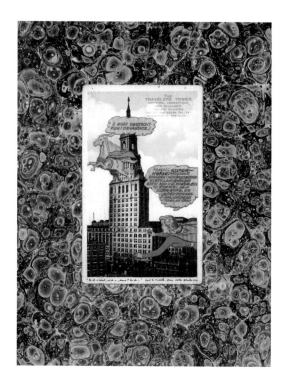

"I spend my life collecting images, newspaper cuttings
and postcards which find their way into my work."
Above, Souvenir for Judith, 1973, from a series of
souvenirs for friends. *Opposite*, sixteen prints from the
Venice Suite, twenty lithographs produced following a
visit in 2007 to the Venice Biennale, after a fifty-year
gap since Blake's first visit as a student.

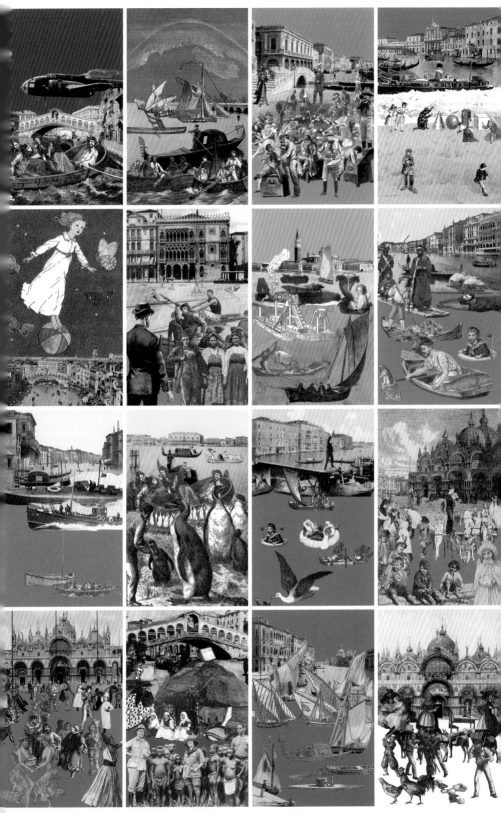

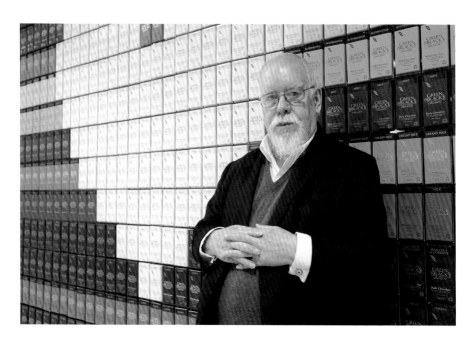

Heart 2009. Sir Peter Blake in front of his Green & Black's commissioned mosaic of chocolate bars.

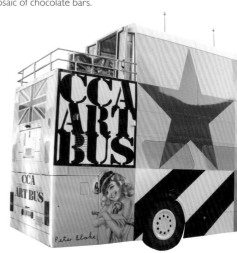

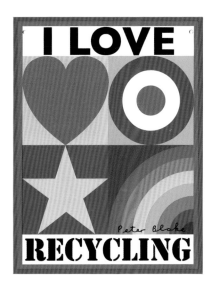
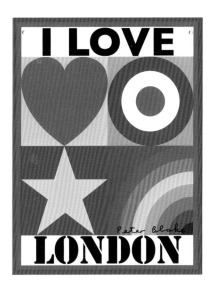

Limited edition tinplates, 2009, commissioned by Creatively Recycled Empire Limited. *Below, CCA Art Bus*, a travelling exhibition project bringing contemporary art to schools, festivals and community centres.

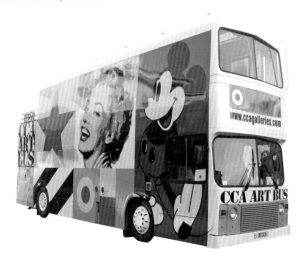